Arthur Baker's
HISTORIC CALLIGRAPHIC ALPHABETS

Dover Publications, Inc.
New York

Published in Canada by General Publishing Company, Ltd., 30 Lesmill Road, Don Mills, Toronto, Ontario.
Published in the United Kingdom by Constable and Company, Ltd., 10 Orange Street, London WC2H 7EG.

Arthur Baker's Historic Calligraphic Alphabets is a new work, first published by Dover Publications, Inc., in 1980.

DOVER *Pictorial Archive* SERIES

Arthur Baker's Historic Calligraphic Alphabets belongs to the Dover Pictorial Archive Series. Up to ten alphabets from it may be used in any single publication or on any single project without payment to or permission from the publisher. Wherever possible include a credit line indicating title, artist and publisher. Please address the publisher for permission to make more extensive use of alphabets in this volume than that authorized above.
The reproduction of this book in whole is prohibited.

International Standard Book Number: 0-486-24054-1
Library of Congress Catalog Card Number: 80-67100

Manufactured in the United States of America
Dover Publications, Inc.
180 Varick Street
New York, N.Y. 10014

An Appreciation
by William Hogarth

What follows is, in effect, a time machine. The student, the enthusiast, is given a marvelous opportunity to return to the beginning of consciously beautiful letter forms, then come forward, viewing the full panoply of historic chronology in alphabet change over the scribe's shoulder. Arthur Baker is not only one of our finest calligraphers, but the inheritor of a tradition, based on life-long study, that permits him, with great empathy, to get under the skin of his predecessors—to feel, react and respond to those places and times in the past two thousand years when new letter forms appeared.

Baker's previous books for Dover, *Calligraphy* and *Calligraphic Alphabets*, made his mastery of the pen delightfully visible. Subsequent publications—*Calligraphic Initials*, *The Script Alphabet* and *The Dance of the Pen*—gave further evidence of his versatility. In *The Roman Alphabet*, Baker triumphantly demonstrated in brilliant fashion his contention that the subtlety of the work of the Roman artisans who inscribed the *capitalis monumentalis* has been unjustly ignored.

The notion of the fixed-angle approach to the line by the tool—whether quill, reed, brush or steel nib—has been most successfully challenged, if not demolished, by Baker in the present book. From the Romans through the subsequent historic manuscript alphabet styles, all of the plates attest cogently to the humanistic view that scribes have always created letters with highly individual sensitivity to form, sometimes even when they themselves denied it, as in the case of the Renaissance artist-critics. Each historic hand has been reinterpreted to emphasize its ideal characteristics; each plate is the apotheosis of the work of a given period—not a mere textbook presentation of actual surviving examples in the manner of the heavy-handed Teutonic *Schriftatlas* compilations, but a truly fresh, highly personal expression by a modern master of form.

Wrong-headedness is a recurring phenomenon. Dürer, Tory, even Leonardo, tried to force the proportion of first-century Roman capitals into a geometrical formula, ascribing the beauty of proportion to the effect of compass and square. They have been forgiven (how deliciously presumptuous, to forgive Leonardo!), largely because the error was based on the rigidity of the chisel, the almost mechanical quality of the masons' need to V-cut the monumental epigraphic letters in marble and limestone, losing the original scribes' fresh, brushed-in form.

Start with the apex of Rome's glory. Look at pages 2–21 as if you were standing behind the scribe-artisan as he snapped a chalk line to guide his hand, and dipped his stiff wedge brush into a pot of red lead paint. What appears on the stone appears here also: the verve and spontaneity of alphabets that live and breathe.

The eighty-eight plates can be studied best in chronological, sequential order. The monumental Roman letters are followed by the scribal variations needed for documents, records, articles of trade and commerce. Later, as the spread of Christianity made the Church the primary source of patronage of artists and artisans, there appear the monastic uncials and half-uncials and the Celtic letters embodied in the glorious *Book of Kells* (pages 30 & 31). Subsequently there are the Carolingian minuscules, which resulted from the felicitous reforms of Alcuin under the patronage of Charlemagne in the late eighth century, coming closer in form to our present-day book typefaces. Those unfamiliar with specific historical terminology can, with profit, turn to general art histories and encyclopedias for further study. The student of letter forms who knows the chronology can benefit most from just turning these pages. It is only slightly off the mark to quote Cyril Connolly's autocratic dictum, "the true function of the writer is to produce a masterpiece"—and not to explain it. That is exactly what Arthur Baker has done.

The names and references that follow have a majestic sonority when spoken aloud: Gothic cursive, versals, Lombardic, Beneventan, bâtarde, textura, rotunda—an adventure in time and place, as learning and its written record brought culture, civilization and an understanding of man's place in the universe to the whole of western Europe.

Finally, in the scholarly humanism of the Renaissance, when men sought to preserve the best of classical antiquity, of Roman law, of Hellenic poetry, of how things and ideas *work*, came the art of the professional writing masters. They codified their craft into art in manuals of instruction. Unfortunately the spontaneity of such masters as Arrighi, Tagliente, Palatino was somewhat lost in reproduction, since in the pre-photographic fifteenth and sixteenth centuries their manuscripts had to be reverse-cut onto wooden blocks by other artisans. Here Arthur Baker's interpretations (pages 82–89) are perhaps most accessible to the great body of new students of calligraphy, for these human-

istic alphabets are the stuff of the primary study of the craft today: chancery cursive, so-called "italic handwriting," the easiest—and, to the knowledgeable, the most easily abused—calligraphic hand.

Since Edward Johnston's revival of interest in the craft of calligraphy at the beginning of the present century, there has developed a contradictory muddle of misunderstanding about historic handwriting. Wrong assumptions have been compounded by disciples of Johnston and other enthusiasts. While craftmanship and good intentions are laudable, such basic errors in original interpretation are unscholarly, fuzzy-minded and even dangerous. Arthur Baker runs the risk in this book of becoming the clear-headed boy in Andersen's tale who pointed out that the Emperor's new clothes didn't exist. Enough analogy! Remember, when you return again and again to *these* interpretative pages, that the historic originals have acted on Baker's own talent and imagination to go beyond them—to add the perfect finishing touch, to summarize a style.

A calligraphic grace note can be compared to a poetic image. In *The Poetics of Space*, the modern French philosopher Gaston Bachelard, who after a lifetime as a professor of natural science turned to commentary on dreams and poetic imagery, wrote: "To compose a finished, well-constructed poem, the mind is obliged to make projects that prefigure it. But for a simple poetic image, there is no project; a flicker of the soul is all that is needed." Look to these pages for visual poetry, lessons of history learned so well that the scribe's absorption and affinity permit almost unconscious, perfect finishing touches—a flick of the pen as well as a flicker of the soul. Arthur Baker has genius, as an artist and as a conservator of the letters which become the words that constitute our only record of civilization on earth. The Roman poet Horace said it best, should calligraphy, or for that matter our brief ascendancy over nature, ever need a defense: *littera scripta manet*. The written word remains.

Arthur Baker's
HISTORIC
CALLIGRAPHIC
ALPHABETS

ABCD

Monumental capitals; reign of Augustus, ca. 4 B.C. *(pages 2–7).*

E F

G H

IJK
LM

N O
P Q

5

R S
T U

V X Y Z

A

BCD

EFG

Monumental capitals; reign of Trajan, early 2nd century A.D. *(pages 8–11).*

HIK
LMN
OPQ

QR
STU
V

V W
X Y Z
Z

ABC
DEF

Narrow monumental capitals; wall writing from Pompeii, not later than 79 A.D. *(pages 12–15).*

GHIJ
KLM

NOP
QRS

TUV
XYZ

AB
CDE
FG

Monumental capitals; reign of Hadrian, 2nd century A.D. *(pages 16–19).*

HIJ
KLM
NO

P Q

Q R S

T T

U V

WXY

YZ

ABCD
EFGHI
JKLM

Rustic capitals; wall writing from Pompeii, not later than 79 A.D. *(pages 20 & 21)*.

NOPQ
RSTUV
WXYZ

A
BCDE
FGHIJ
KLM

Square capitals; 4th century A.D. *(pages 22 & 23)*.

NOP
QRST
UVW
XYZ

A
BCDEF
GHIJK
LM

Rustic capitals; 4th–5th century *(pages 24 & 25)*.

NOP
QRST
UVXY
Z

A

BCDE

FGHIJ

KLM

Roman uncial hand; 4th–6th century *(pages 26 & 27)*.

NOP

QRST

UVW

XYZ

a b c d
ij k l m
r s t u v

28 Roman half-uncial hand; 5th–6th century *(pages 28 & 29).*

ersh
nopq
wxyz

abcd
ijklm
rstu
xy

Irish half-uncial; from the *Book of Kells*, 8th–9th century *(pages 30 & 31).*

efgh
nopg
vwx
z

abcdef
nopqrst

Anglo-Saxon minuscule, pointed script; 8th–9th century *(pages 32 & 33)*.

ghijklm
uvwxyz

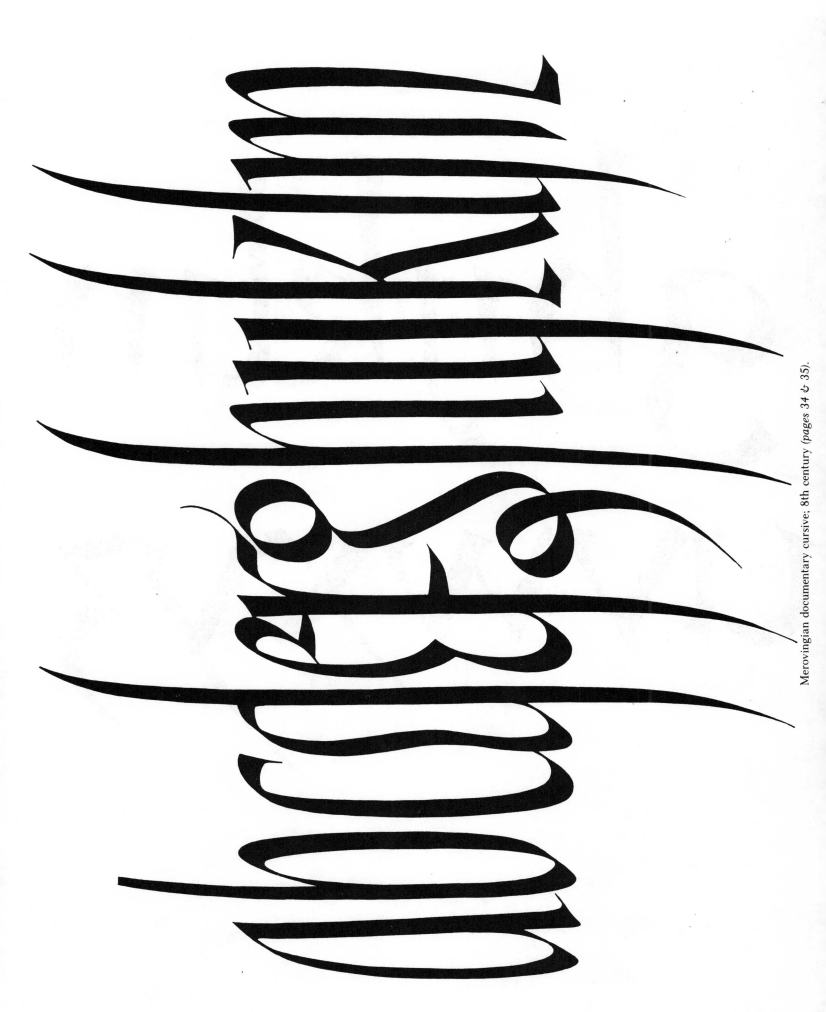

Merovingian documentary cursive; 8th century (*pages 34 & 35*).

34

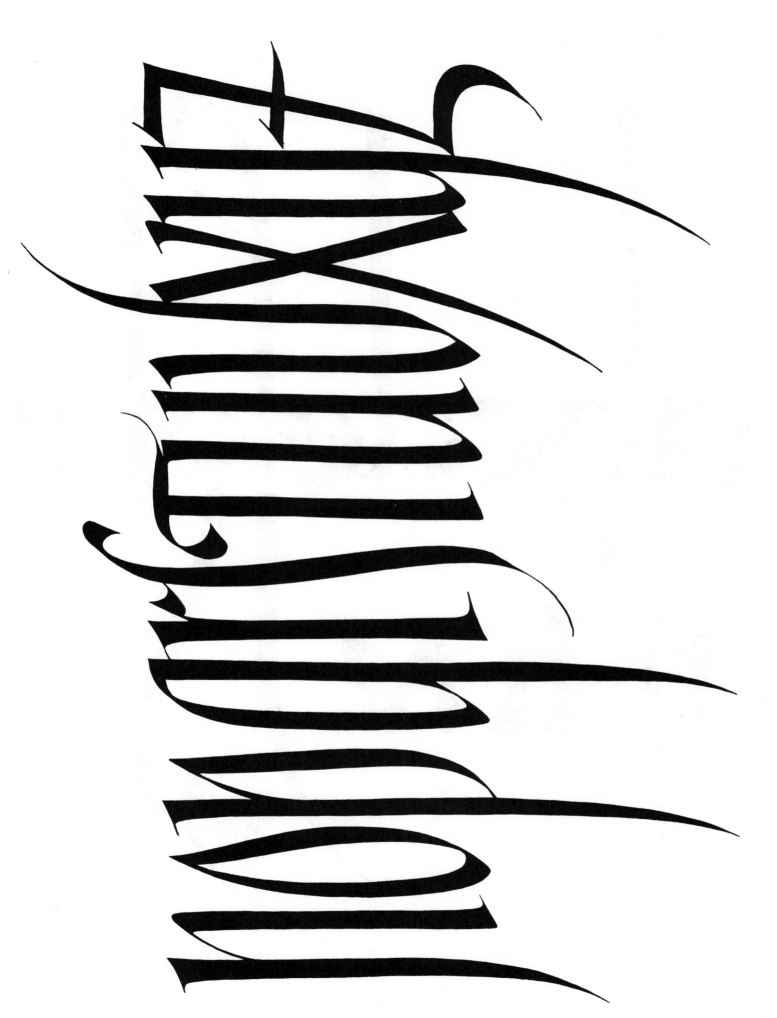

Carolingian documentary cursive; 10th century *(pages 36 & 37).*

jklmnopq
wxyz ß

abcdefghi ss qrstu

English diplomatic Gothic cursive; 13th century *(pages 38 & 39).*

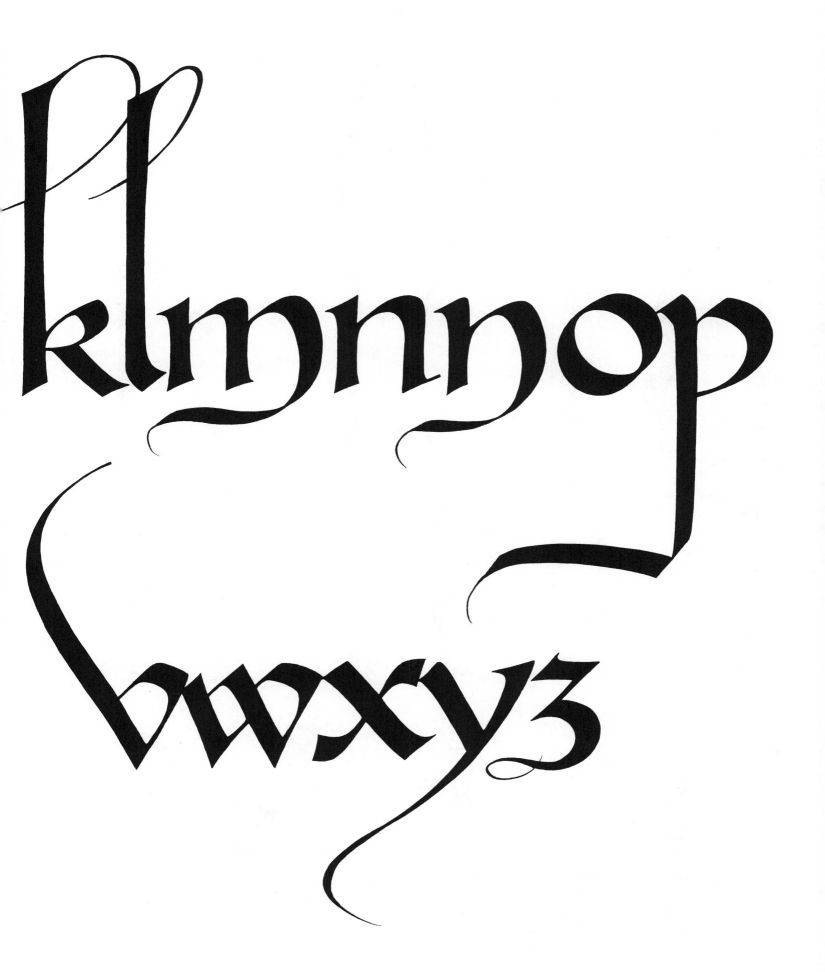

ABCDE
BCDE
FGHIJ
KLM

Versal majuscule; 9th–13th century *(pages 40 & 41)*.

NOP
QRST
UVW
XYZ

ABC
chij

Carolingian uncial; 8th–9th century *(pages 42–45).*

ðeꜰ
klꝳ

NOP
TUV

QRS
XYZ

abcd

klmno

uvw

Carolingian minuscule; 10th century *(pages 46 & 47)*.

efghij

pqrst

xyz

ABCD
EFGHI
JKLM

Narrow Lombardic majuscule; 12th–13th century *(pages 48 & 49)*.

NOPQ

RSTUV

WXYZ

abc
defghi
jklm

Early Gothic minuscule; 12th century *(pages 50 & 51).*

nopq

rrstuv

wxyz

A
BCDe
FGhIJ
KLM

Lombardic majuscule; 12th–14th century *(pages 52 & 53).*

NOP
QRST
UVШ
XYZ

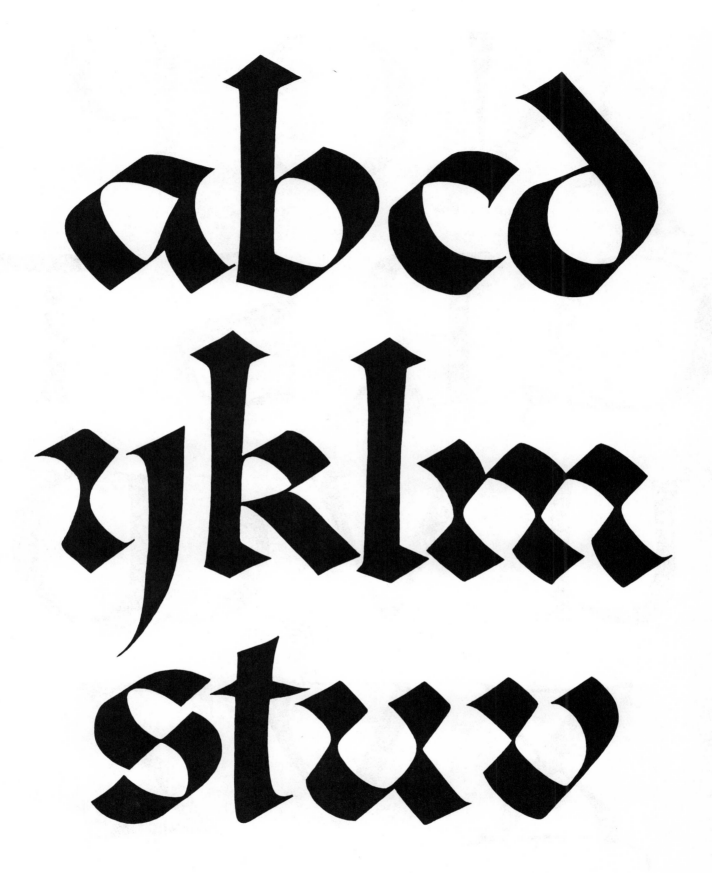

Lombardo-Beneventan minuscule; 11th century *(pages 54 & 55).*

efgh

nopqr

wxyz

Gothic majuscule; after Dürer, 15th century *(pages 56–58)*.

abcdefg
hijklmno
pqrstuv
wxyz

Gothic minuscule; after Dürer, 15th century.

Bâtarde majuscule; 14th–16th century *(pages 60–62)*.

K L M
N O P
Q R S

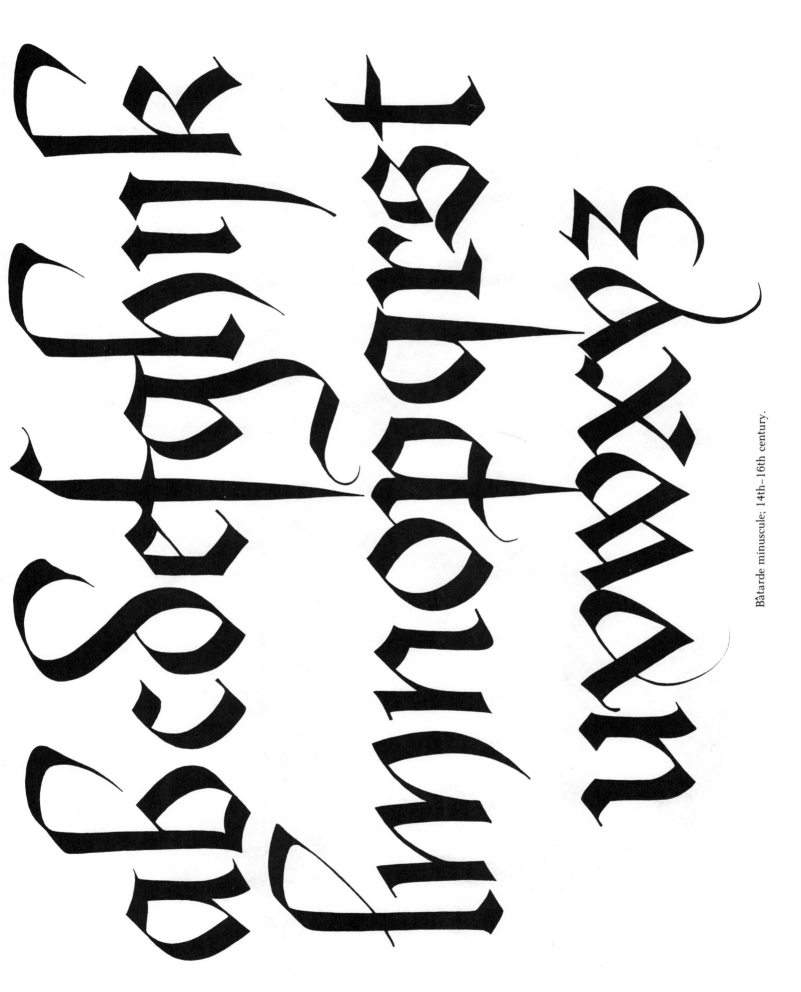

Bâtarde minuscule; 14th–16th century.

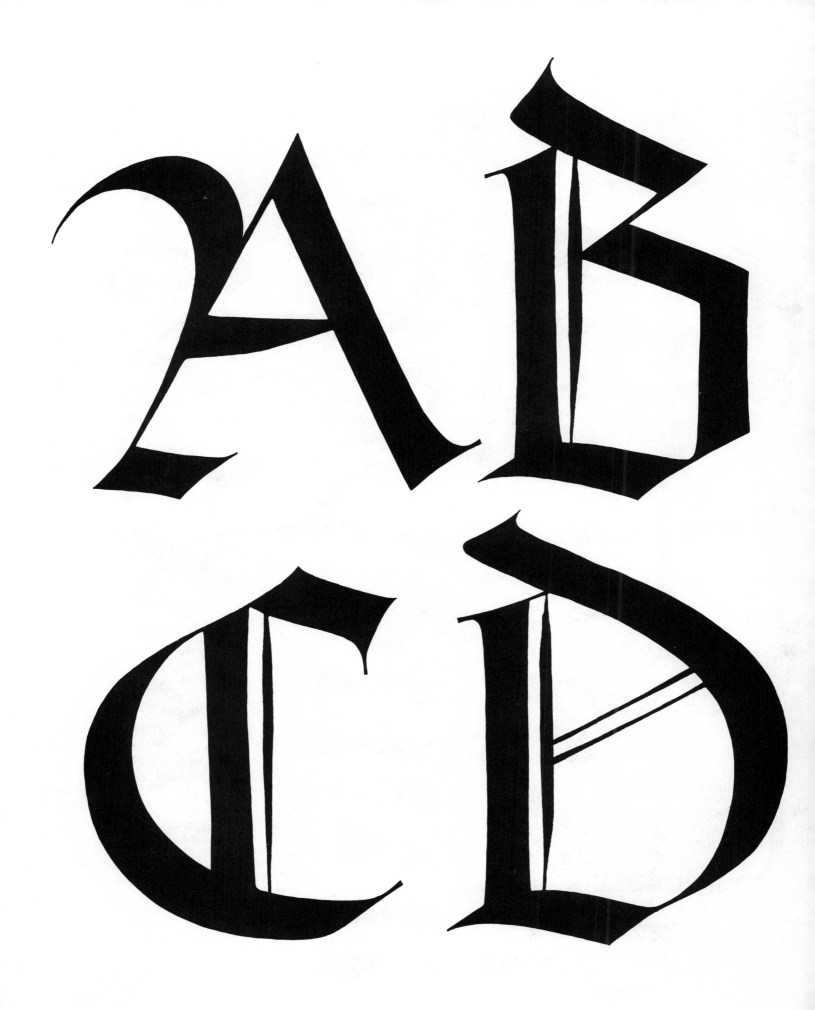

Textura majuscule; 15th century *(pages 64–69).*

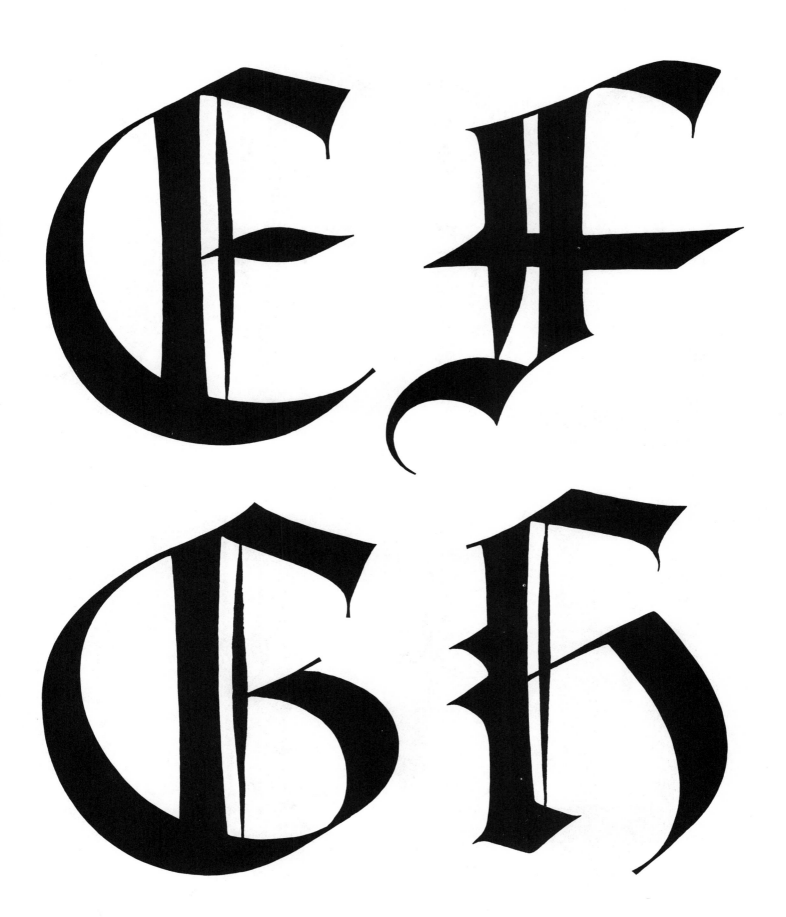

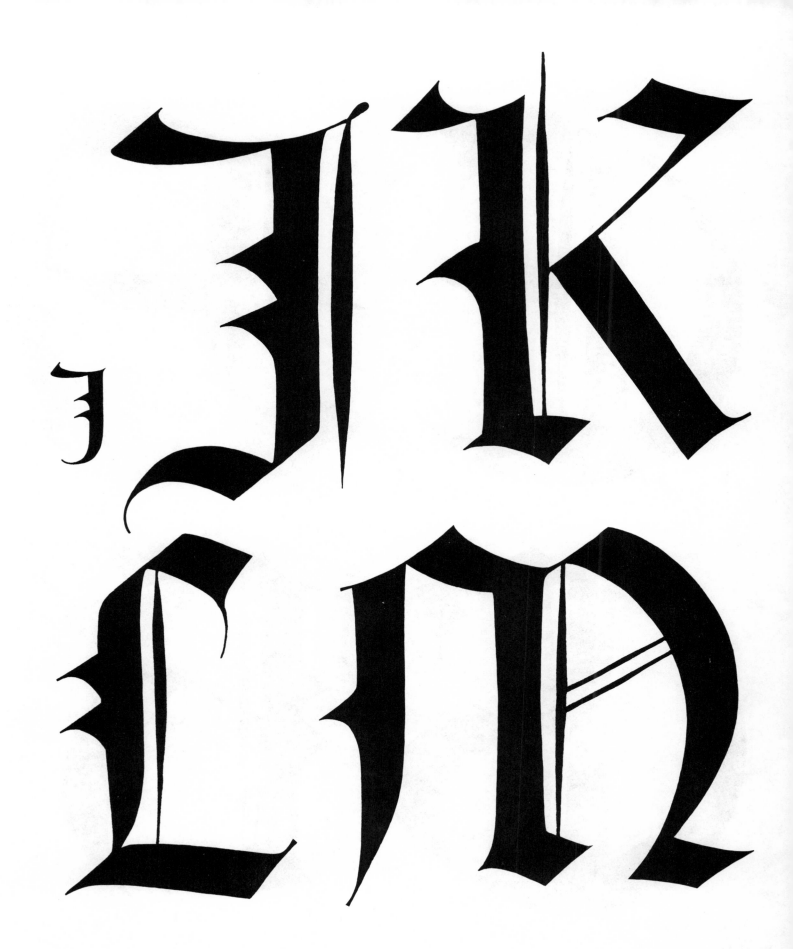

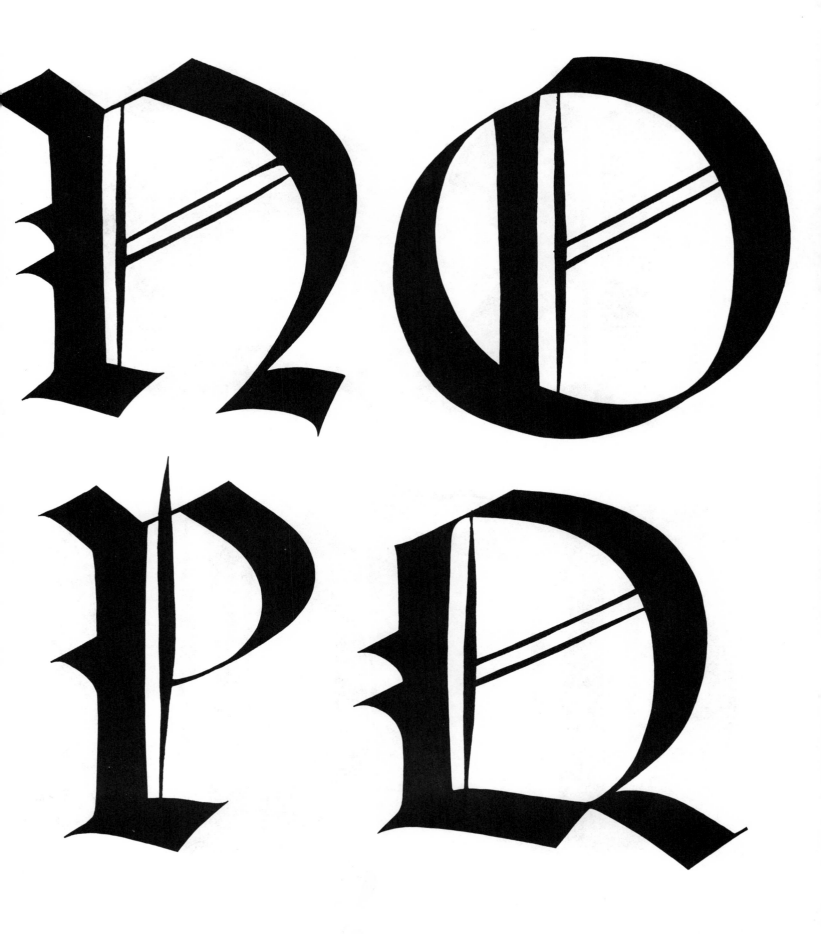

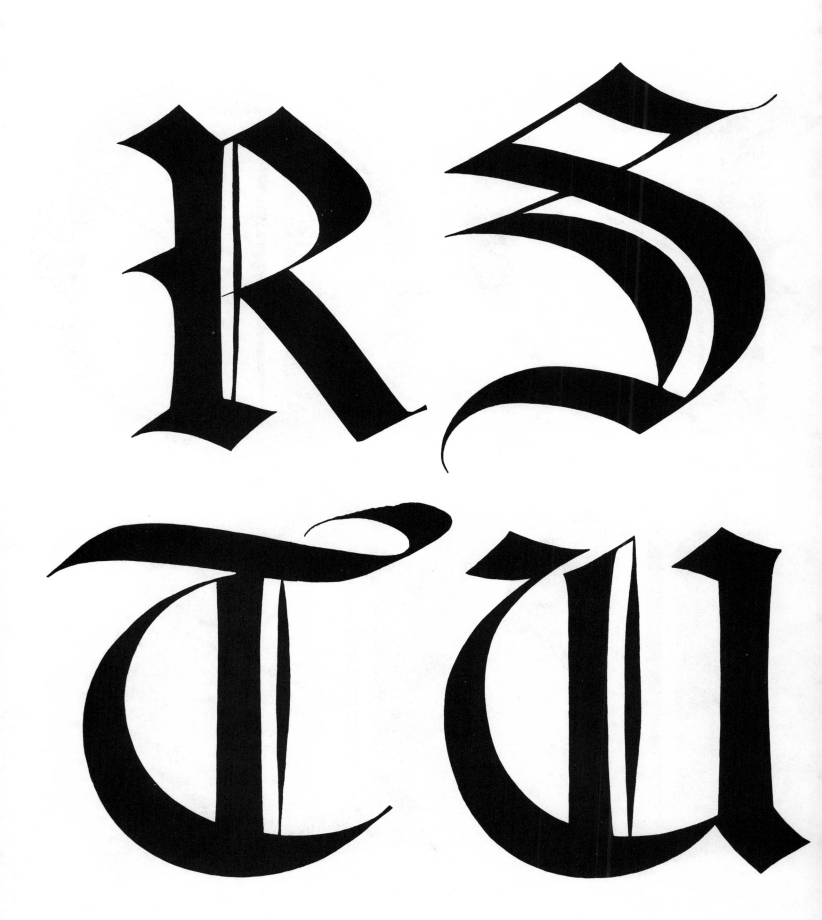

W w E

P Z

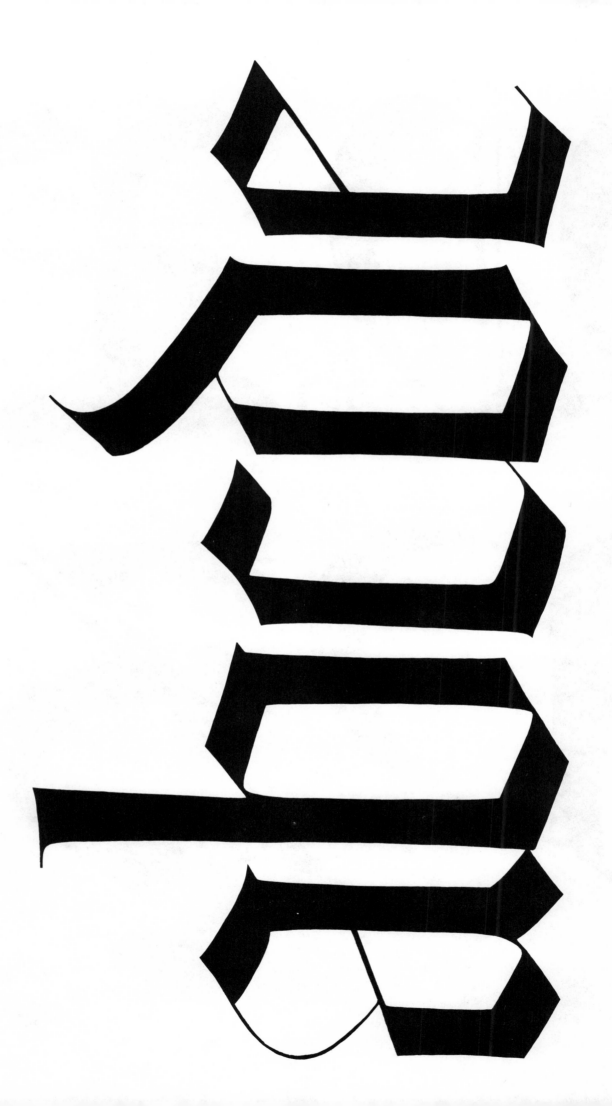

Textura minuscule; 15th century *(pages 70–75)*.

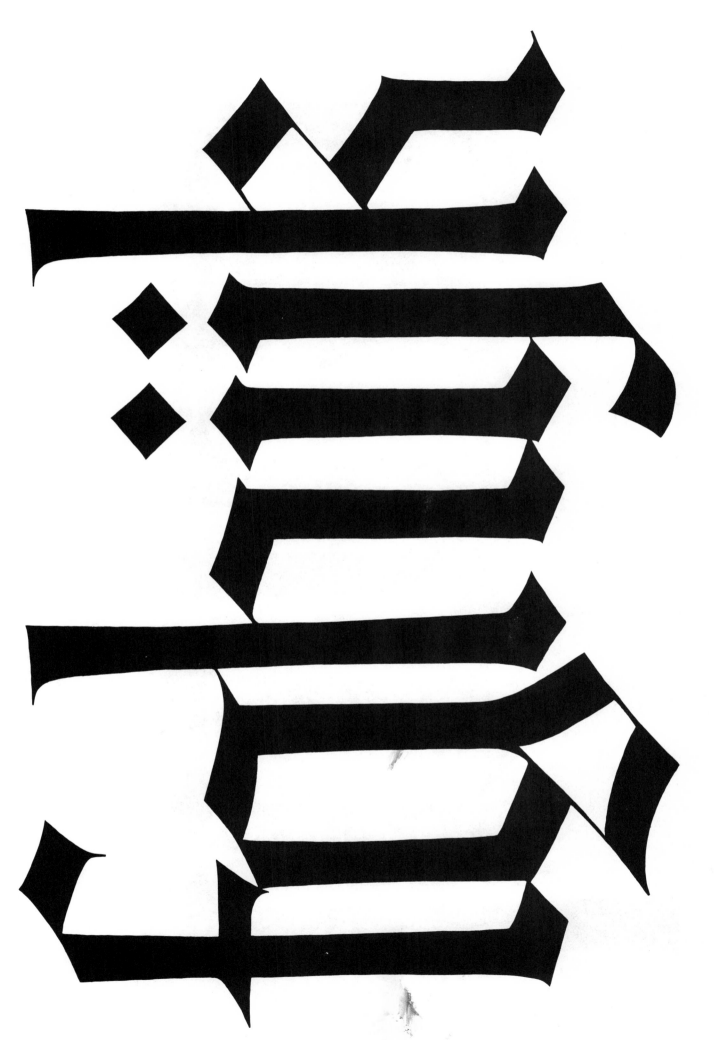

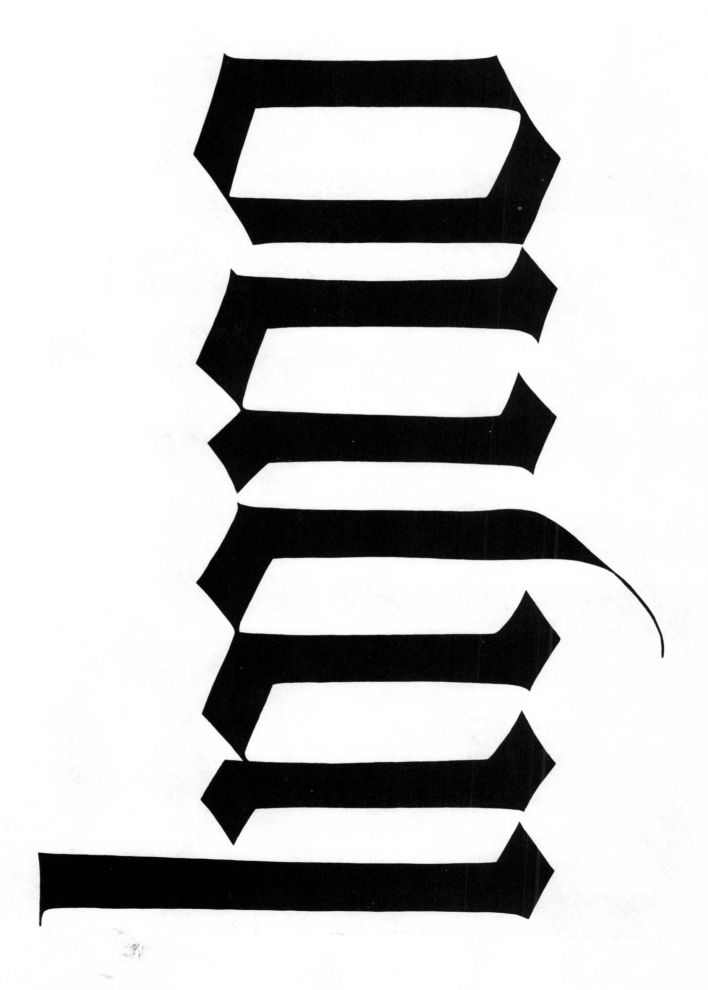

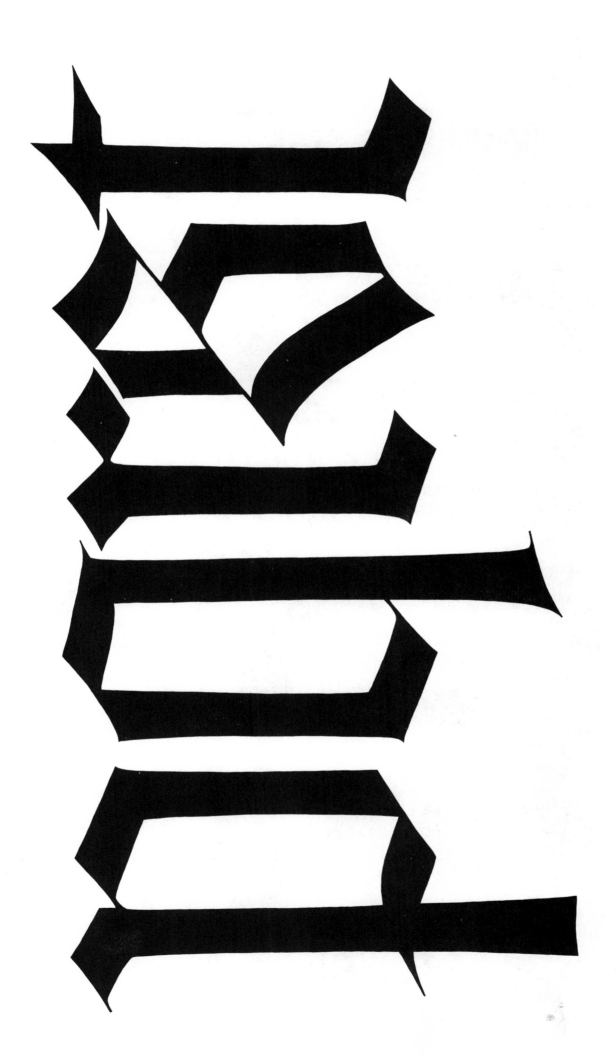

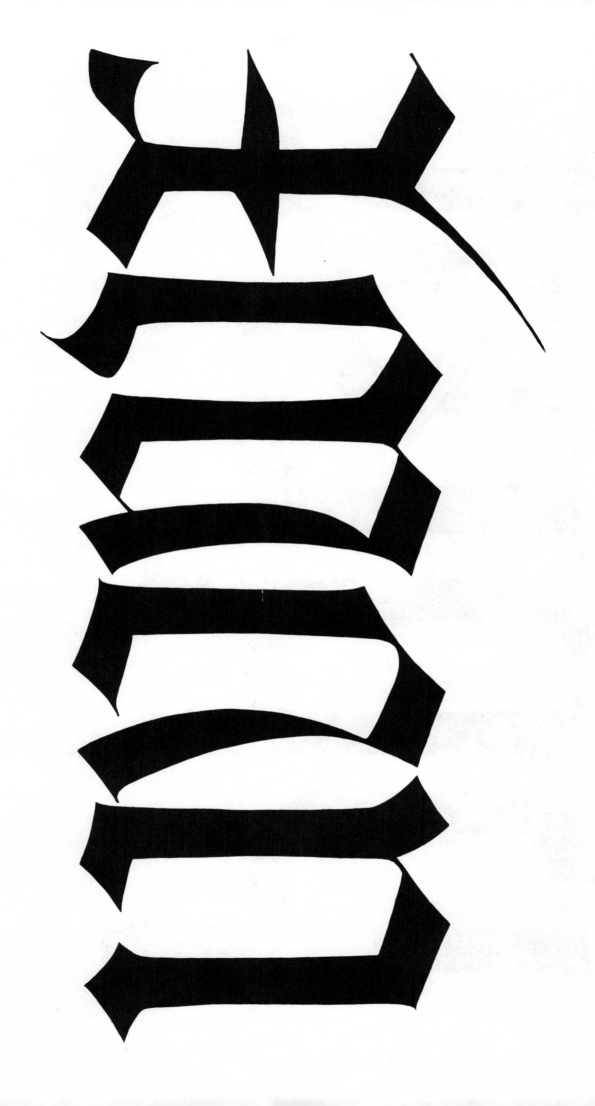

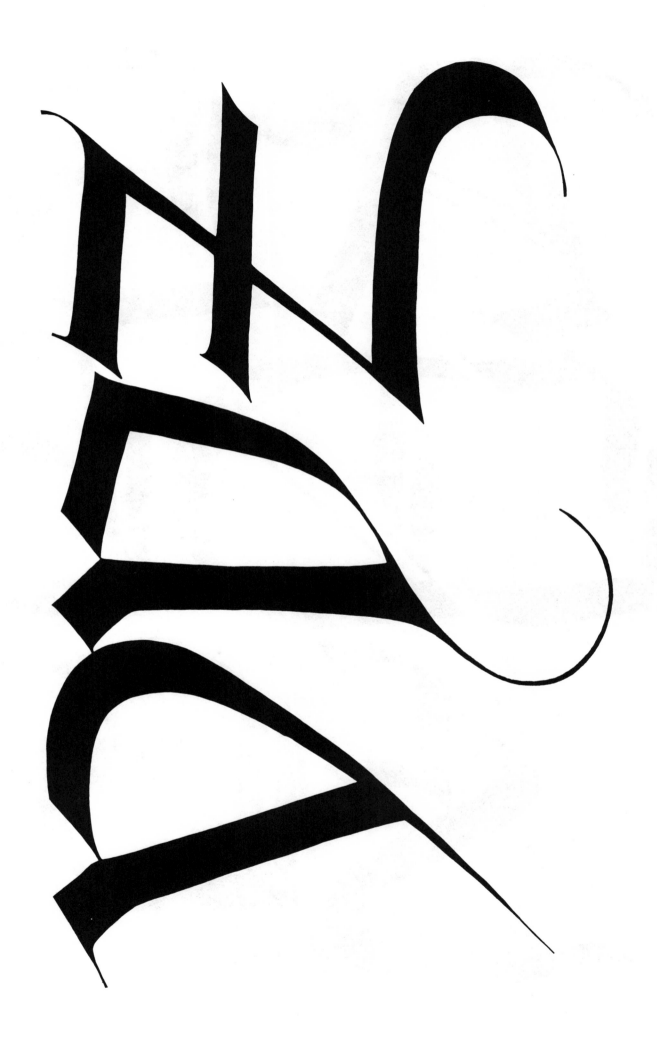

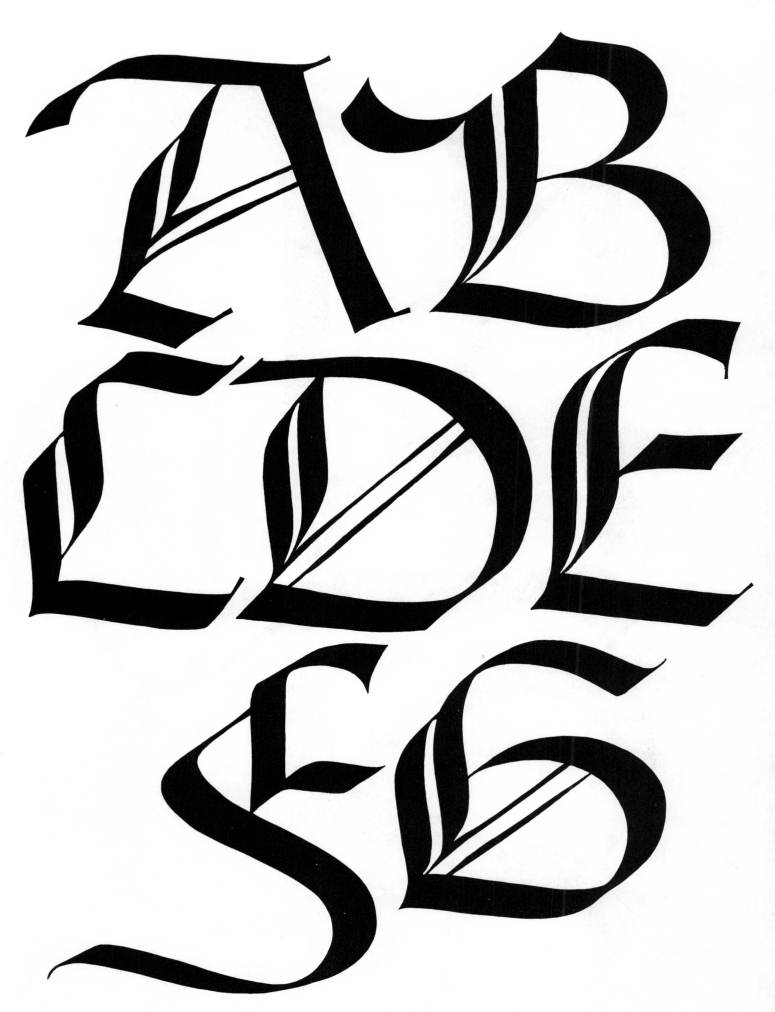

Rotunda majuscule; 15th–16th century *(pages 76–79)*.

abcd

jklm

rstuv

Rotunda minuscule; 15th–16th century *(pages 80 & 81).*

efghí
nopq
wxy3

A
BCDE
FGHIJ
KLM

Humanistic majuscule; 16th century *(pages 82 & 83)*.

NOP
QRST
UVW
XYZ

abcde

mnop

wx

Humanistic minuscule; 16th century *(pages 84 & 85)*.

fghijkl
qrstuv
yz

ABC
DEFG
HIJK
LM

Humanistic cursive majuscule; 16th century *(pages 86 & 87)*.

NOP
QRST
UVW
XYZ

abcdefg

nopqqr

xy

Humanistic cursive minuscule; 16th century *(pages 88 & 89).*

ghijklm
stuvwx
yza